Dedicated
to the Treasured Memory
of

My Grandmother *and* *My Great Aunt*
Ivy McAviney *Averil Hall*

Theresa Hernandez
8447 Artson Street
Rosemead, Calif. 91770

ACKNOWLEDGMENTS

I wish to take this opportunity to thank those people whose generosity, encouragement, and assistance have made this book possible:

My husband Len and my children Melanie, Heike, Crystal, Reiner, and Silka.

Doxie Keller, Jane Peterson, Jill Liljenquist, Rose Fowler, and Jackie and Lynn Shaw.

All my friends from the Creative Artists of Central Florida and the Australian National Capital Decorative Artists, both chapters of the NSTDP.

Deco-Art, Accent, Chroma Acrylics, and J.W. etc.—paint companies that so generously provided supplies for these projects.

All my students over the years whose enthusiasm and friendship has spurred me ever onwards and all the friends I have made both in Australia and USA through our mutual love of painting. May God bless and keep you always.

Gus Dovellos of Royal Brush for having faith in me from the very beginning, for asking to be given an opportunity to attempt the development of my "Magic Brush," and for coming through.

Particular thanks to Enid Hoessinger, my dear friend, teacher, and colleague, for teaching me the thirteen strokes, sharing her techniques with me, and for giving me the encouragement and confidence necessary to further develop and create designs and techniques of my own.

TABLE OF CONTENTS

BEFORE YOU BEGIN

The purpose of this book is to show you how much you can do with so little. With just one brush and the knowledge of thirteen brush strokes you can create an endless variety of flowers and foliage. You can also design your own decorative schemes to fit any shape and select pleasing colors to match any decor.

You will also find scattered through the book photos of eight painted pieces and their patterns. I have included these as examples of the techniques you will be learning. If you are interested in painting the specific pieces, you will find sources listed on the next page. With this type of technique it is quite difficult to identify specific colors on the patterns. You will be readily able to determine how they were painted, however, once you have studied the color worksheets in Chapters 6 and 7 and the table of color combinations in Chapter 8.

The painting technique that I use is entirely based on stroke work, multiple loading, and brush control. There is no need for shading, highlighting, floating color, dry brushing, etc., as all color variation and detail is achieved in *one stroke* using only *one brush*. Fine detail is sometimes used on leaves and is done with the tip of the brush brought to a "knife" edge. You may notice that I have not listed a liner brush among the requirements and this is because I never use one. Wonderful results can be obtained using the multi-loading technique, and many layers and colors may be loaded onto the brush at once; however, I will not deal with more than three or four at once in these instructions. Steps such as "dribbling" the white and "pushing" color into the brush will probably need to be practiced if unfamiliar. Therefore, I urge you to place a clear plastic sheet over the color worksheets and paint right on top of the samples. The paint will wipe straight off with a damp cloth.

As I depend solely on one brush for everything, it needs to be of an exceptional quality. I have tried just about every brush on the American and Australian markets and find that a high quality sable brush will give the desired results. The brush needs to have a well-defined point and must snap back to a point easily and quickly. Some good quality synthetic/sable blend brushes may also give good results, but they do not last as long.

As it is probable that all who obtain this book will not already be familiar with the 13 strokes on which the technique is based, I will offer a few pointers. The lovely effects of the blending and streaking in the flowers are gained by allowing the brush to *open* out before moving it through the stroke. Don't be afraid to push the brush down and wait for those bristles to spread. If you find the bristles won't spread, then you definitely do not have enough paint in your brush. Do be careful not to exert **too much** pressure on the heel of the brush as this may cut hairs off at the ferrule.

You may feel that your brush is overladen with paint whilst painting in this style, but this is necessary. Using a gentle, slow movement will prevent "losing the white" on the first stroke whilst painting the flowers. Always keep the paint fresh and moist. Use a wet palette to help achieve this.

I cannot stress strongly enough how important it is to practice and perfect the thirteen strokes. This will train you to have perfect control of the brush which in turn will make anything possible. The strokes, along with foliage and flowers, are demonstrated in the Deco-Art video titled *Melinda's Folk Art—Rococo Techniques, #1*. For a more in depth explanation of the thirteen strokes I refer you to *Folk Art with Enid—Introduction To Multi-Loading, #1*, another of the Deco-Art video series which deals only with mastering the strokes and shows them in detail.

Please do not be discouraged if at first you are unable to achieve wonderful results. This is to be expected with any new technique and especially this one. You will find this style of painting very different from any you may have used previously.

Mastering this technique will require dedication, determination, and practice; but, whatever it takes, please persevere as you will be truly rewarded for your efforts—this I promise!

Melinda

GLOSSARY OF TERMS

"Knife" edge. Flatten the brush to a sharp chisel shape whilst loading the paint.

"Cut" with the knife. Using very *light* pressure, stroke fine lines by pulling down on the "knife" edge.

"Pick up" white. First, load the brush with the required colors for a flower. Take the brush to the *top* (side furthest away from you) of the puddle of the white. Now push one side lightly against the paint and pull the brush towards you. The white should sit on the brush resembling a fingernail, about half the length of the bristles.

"Pull through" a color. First, load the brush with the main color required for a flower. Take the brush to the *bottom* (side closest to you) of the puddle of paint. Now, with the handle of the brush pointing towards you, pull a little of the paint out of the puddle onto the palette. Stroke the brush to a knife edge as you do this. The paint should appear smeared on the brush for about half the length of the bristles.

"Push in" the color. First, either pick up or pull through a *small* amount of paint onto the previously loaded brush. Then, touch it down against the palette to push (blend) the new color into the first.

"Dribbling" the white. With the main flower colors loaded onto the brush, pick up a generous amount of white. Touching the tip of the brush to the surface, exert and release pressure gently as you move the brush around the desired shape of the flower. Push towards the white side of the brush as you do this, allowing little blobs of white to drop from the brush onto the surface.

SOURCES

The patterns in this book can easily be adapted to any surface. If you should want to paint a specific piece, however, you may use the following sources:

Medicine Cabinet
Rosy Fowler
107 Shadow Trail
Longwood, FL 32750
(407) 332-6984

Wall Clock
Trio Designs
PO Box 568547
Orlando, FL 32856
(407) 282-1518

Canvas Notebook Cover
Dalee Book Co.
267 Douglass St.
Brooklyn, NY 11217
(718) 852-6969

Papier-maché Six Sided Box
Decorator and Craft Corp.
428 South Zelta
Wichita, KS 67207
(800) 835-3013

Metal Trays — The ones in this book were "found," but they are similar to the 11" x 15" cut corner tray produced by:
Crafts Manufacturing Co.
72 Massachusetts Ave.
Lunenburg, MA 01462
(508) 342-1717

Scalloped Plate — Also "found," but similar to the 16" petal plate sold by:
Viking Woodcrafts, Inc.
1317 8th Street S.E.
Waseca, MN 56093
(507) 835-8043

Stool — This came from a friend's kitchen. You can find them in stores that sell wooden furniture.

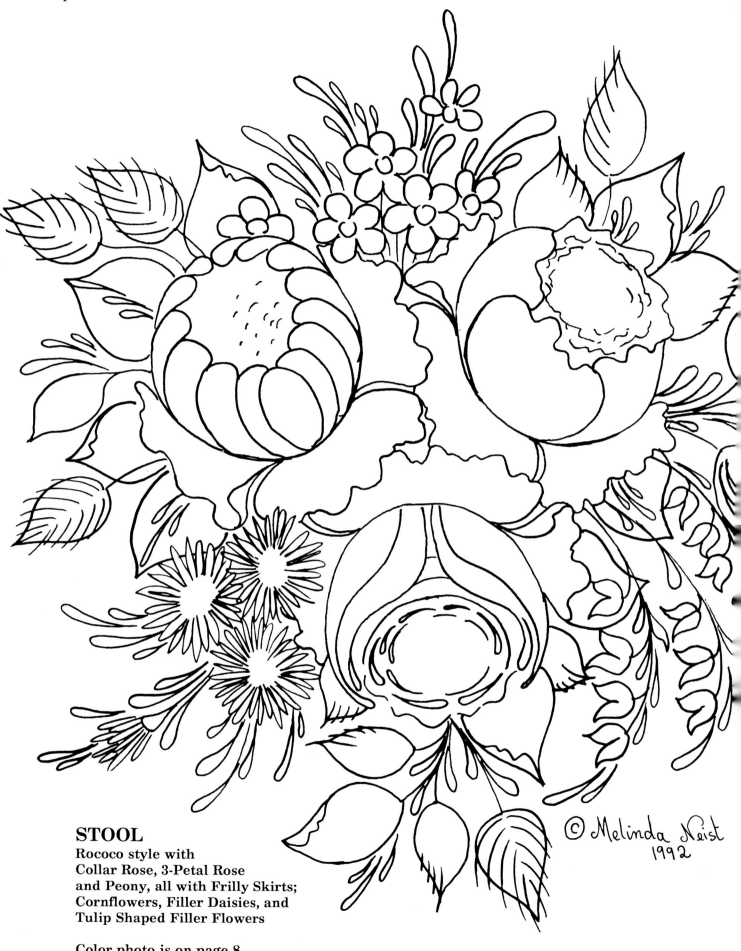

STOOL
Rococo style with
Collar Rose, 3-Petal Rose
and Peony, all with Frilly Skirts;
Cornflowers, Filler Daisies, and
Tulip Shaped Filler Flowers

Color photo is on page 8.

© Melinda Neist
1992

Chapter 1
FIRST, A LITTLE HISTORY

Throughout the centuries folk art has been influenced by events and social pressures that have moved the world. Several eras have passed and as the art form spread throughout Europe, master craftsmen from the various villages applied their preferred techniques and styles to individualize their painted decoration.

In its early stage, this art form appeared as a rather flat, but not untidy, naive style known as **Baroque** which had an almost childlike charm. The designs, being somewhat symmetric for the most part, frequently displayed strong religious symbolism. The tulip, which represents the Holy Trinity, was often featured as was the rose, the symbol for Christ's love. Other symbols included the urn, representing life giving water, and the heart, a symbol of God's love. When viewing painted decorations of the Baroque era, the individual strokes are often quite apparent and little attention was given to perspective. Frequently an urn may appear too small to support the floral arrangement it contains. Colours were bright and bold, and furniture was often quite "busy" with all available space decorated.

The more realistic decoration of the **Rococo** Era displays a definite French influence. Rococo became very popular amongst the German, Austrian, and Swiss nations. Colours softened and became delicate, while backgrounds became lighter, even pastel in shade. Flowers and foliage were more exotic and varied than the earlier decorations and included scrolls, shells, scenes, roses, and a multitude of other flowers. Faux marble featured quite strongly during this era.

The beautiful decorations of the **Empire** Era have always been a favorite of mine. Flowers frequently appeared more open and squat and became quite pale, often almost white in shade, with just a hint of the desired colour. France was still a major influence as the style spread throughout Europe at the hands of master craftsmen who were keeping up with the fashion demands of the time. Common features included ribbons and bows, garlands, urns, scrolls, drapes, swags of flowers and leaves, medallions, and scenes. Marble effects were still very popular and imitation timber finishes were also employed. However, the Empire decoration had a more delicate and subtle appearance than the sometimes heavy, Rococo style. Backgrounds were still light, leaves and flowers were soft, and few colours were used in a design. Often, several shades of a single colour were used to define different flowers in a group.

A quiet elegance best describes the **Biedermeier** Era. Imitation timber backgrounds depicting exotic veneers, fruit woods, mahogany and walnut burl were very popular. The floral decorations were understated, yet beautiful, and never overly elaborate, as was evident in earlier styles. Decorations were often quite small and were applied to fewer areas of a piece.

The ability to look back over the developing years to choose the style in which we prefer to decorate is a privilege we can now enjoy. Distinguishing between the different styles and eras will become easier as this art form is studied and understood.

As the various flowers and features become familiar, the differences will become apparent. When choosing which style to apply, always remember this important point:

*Consider the **type** of article you wish to decorate!*

If I were going to decorate an old milk can, which would be considered a rustic, more earthy piece, I would not use an elaborate Empire motif. Instead, I would apply a Baroque, or maybe an early Rococo design that is not too elaborate. I would keep the Empire design for a lucky find, such as an elegant hall table with thin, beautifully turned legs. Keep this simple advice in mind when choosing your designs as it is important if you wish your work to have a pleasing and harmonious overall effect. An elaborate Empire design on an old, dented coal shuttle would only serve to confuse the eye, as one contradicts the other.

In passing, I have touched only very lightly on the various styles and eras of this beautiful art form. I urge you to research further the history and life of European Folk Art. The history is very interesting, and much can be learned about the painting techniques by reading about and studying photographs of old pieces. It's also a whole lot of fun!

Chapter 2
SURFACE PREPARATION, ANTIQUING, AND FINISHING

SURFACE PREPARATION

Different surfaces require different preparations. I will describe the techniques I use most often in preparing my pieces. Proper preparation is extremely important for a successful and happy ending. Nothing could be worse than spending a lot of time and effort on a piece only to find that within six months poorly treated rust starts to bubble up through your beautiful work. Another horror story could involve discovering that your base coat has not adhered to the surface of, say a lovely entry table, and every time a lamp or ornament is moved on the table, some of your artwork is peeled back.

Such disasters can be avoided by taking the time to correctly prepare your surface. If your time is limited and you intend to prepare a large furniture piece, you may wish to consider seeking professional help. I have had several large furniture pieces dipped in a non-caustic furniture bath and have been very happy with the results, and the time saved. Such a bath will remove all traces of paint and oxide build-up, and the piece is returned ready to base coat. This process is also successful for paint removal from metal pieces. However, if you have the time and prefer to do it yourself, I have had success with the following methods. The work may not be as bad as you expect.

Old Rusty Metal Items (with or without paint). Sandblasting is the best solution. If you don't have the required equipment, you can hire it, or you can take your piece to a professional workshop. I have discovered that many car smash repair yards will sandblast items for a reasonable price. The items are usually returned primed and ready for a base coat.

If sandblasting is not an option, a sturdy wire brush can be used to remove as much flaking and rust deposits as possible. The piece should then be dusted thoroughly. If the weather is hot and dry, you can hose it. When completely clean and dry, coat the piece with either a rust converter or rust inhibiting metal primer. I have always found the staff in local hardware stores to be very knowledgeable and helpful in choosing an appropriate primer.

Once a metal primer has been applied and allowed to cure, the piece is ready to base coat with a *flat* or *matte* finish enamel paint. I usually prefer to use spray cans, as this saves time and avoids messy clean-up of brushes, etc. Enamel paints are my preference as they have better adhesion to primers. I have unhappily discovered that sometimes water-based base coats will lift with the slightest of knocks. Always follow manufacturer's instructions and allow sufficient curing times between coats. If using acrylic, water-based paint for your base coat, mix 1 to 1 with sealer for better adhesion.

New Metal Items. Wash all new metal thoroughly with soap and water. If the item has a galvanized finish, wash it down with vinegar and water to remove the greasy residue left by the galvanizing process. Choose the correct primer and spray or paint the piece. It is necessary to use special primers that are available for galvanized metal because the outer layer of the metal can remain active for some time. On an incorrectly primed surface, white spots might appear on the surface after about three months. Once the primer has cured, base coat the item with a flat or matte enamel paint as previously described.

Wood Items. Raw, unpainted wood should be basecoated with acrylic, water-based paint using a mixture of one part sealer to one part paint. Apply two coats, allowing sufficient time between coats for the first coat to dry completely. Sand lightly before applying the second coat.

Painted or varnished wood needs to be stripped. Or, have the old surface finish sanded back to ensure there is no peeling or flaking, and to remove any uneven spots. Fill all cracks and holes with a good quality wood filler. When the filler is dry, sand until smooth. Repaint as described for raw, unpainted wood.

Continued on page 11

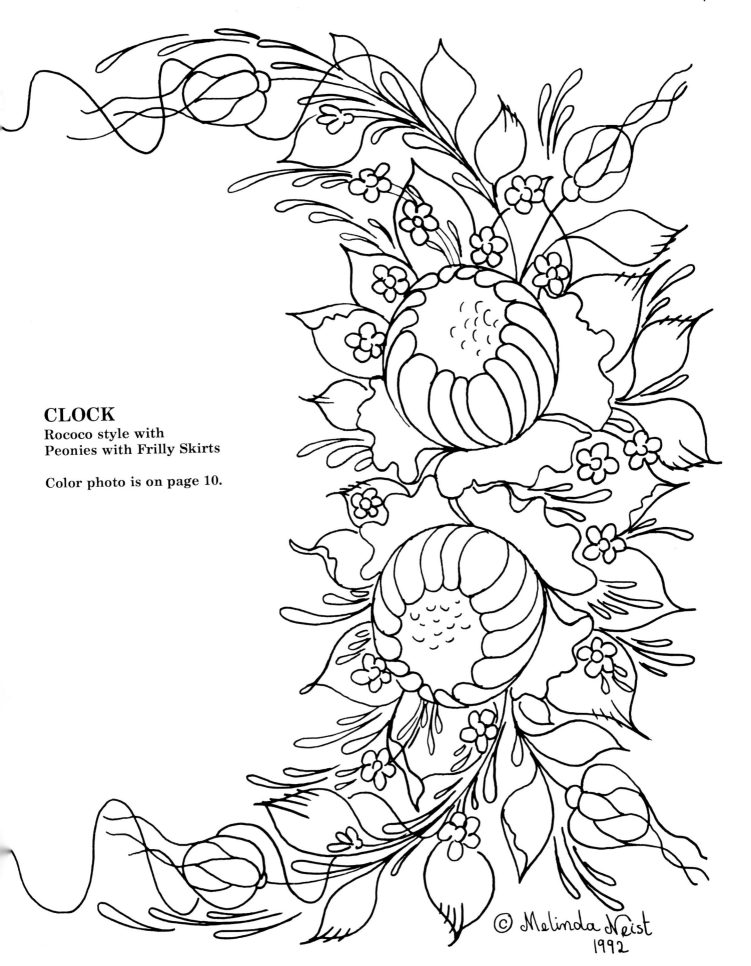

CLOCK
Rococo style with
Peonies with Frilly Skirts

Color photo is on page 10.

STOOL
Pattern
on page 4

CLOCK
Pattern
on page 7

ANTIQUING

I usually antique my finished pieces. Two methods are in common use; one is an oil-based method and the other is a water-based method. I prefer the oil-based method and will describe the steps involved. However, if you wish to try the water-based method, there are several good products on the market and you can follow the manufacturer's recommended steps which will be found on the label.

The oil-based method is applied as follows:

1. When your painted piece is completely dry, seal the piece using a matte finish spray sealer. Allow to dry thoroughly before continuing.

2. **Oil Patina Medium.** In a small bottle, combine 4 parts gum turpentine with one part refined linseed oil. Keep a little gum turpentine aside in a separate jar for brush cleaning.

3. Squeeze a small amount of oil paint from a tube onto the surface of the piece. I use Burnt Umber for most pieces. However, if my piece is mostly blue, I use Paynes Gray. Using a large, stiff bristle brush, moistened with the patina medium, scrub the paint over the entire surface. Sufficient paint should be used to entirely hide the design when spread out. Use the patina medium sparingly, as it is only meant for use as a vehicle to help spread the paint. The mix should not be runny, but should have a light, creamy consistency. Extra paint and patina medium can be applied as required to cover the surface.

4. Using a lint free cloth rolled up into a pad, wipe excess paint from the surface (old T-shirts are good for this). Starting in the center of the design and exerting some pressure, move in a circular motion spiraling outwards, releasing pressure as you move towards the outer edge. Repeat this process until the desired amount of antiquing has been achieved. Releasing the pressure towards the outer edge causes less paint to be removed and darkens the antiquing giving a realistic, old appearance.

5. Flowers can be highlighted by rubbing away more antiquing where necessary. If the finish appears too dark and no more antiquing will rub off, simply add a little patina medium to the cloth and rub over again.

FINISHING

When the final desired effect has been achieved, spray with a satin finish varnish to seal and protect the piece. I like to use Minwax Satin Polyurethane which is available at most major hardware stores. Two coats are usually enough, and remember—when spraying any type of paint or varnish, do so in a well-ventilated area and use a mask.

If you have used a water-based antiquing method, you may wish to use a water-based varnish. There are several brands readily available. I have had excellent results with Deco-Art's Americana Acrylic Sealer/Finisher (matte spray), Deco-Art's brush-on varnishes, and all of the J.W. etc. brand.

A few important points to remember when varnishing:

1. Be sure that you have removed all graphite and chalk lines before you apply varnish.

2. If you are using a spray can to apply varnish, avoid applying it on a rainy day as high humidity can cause oil-based varnish to appear milky white in places.

3. If you are using a paint-on varnish, *do not shake* the container before applying. This can cause tiny air bubbles which are difficult to remove and are sometimes evident only after a coat has been applied. You will find it is best to slowly stir the varnish if mixing is required, or, lay the bottle on its side and roll it back and forth.

4. Always use a large, soft, flat brush to apply varnish. Painting in one direction only. Allow at least 20 to 30 minutes between coats for water-based varnish to be sure it is dry.

CAUTION

Please always remember to observe manufacturer's safety warnings when using spray cans and varnishes as they can cause irritation and allergic reactions. I recommend the use of a filter mask when using these products.

Chapter 3
CREATING YOUR OWN DESIGNS AND TRANSFERRING PATTERNS

Several patterns have been included in this book, but I hope to inspire you to create your own unique designs. When selecting a pattern or creating a new design for the piece, you will need to consider its shape, size, and function. The era of your chosen design must also be considered.

Baroque Era usually demands a symmetric design which is always placed in the center of the piece. Triangles appear in the Baroque designs relating to either colour or flower type or a combination of both, as demonstrated in Figure 1 below. This type of design always appears very orderly.

Asymmetric design is more interesting and can be seen in the later eras of folk art such as Rococo, Empire, and Biedermeier. These designs are still very balanced and harmonious. An asymmetric design has a focal point that is usually not centered and can be adapted to fit any shape or size area. See the examples in Figure 2 below.

B - Blue
R - Red
Y - Yellow

Figure 1. Symmetric Design (Note the triangles of color and of flower type)

Figure 2. Asymmetric Design

When creating a design, a good idea is to cut several pieces of paper into the shape of the item or area to be decorated. Draw curved lines within the shapes, and then design around the curve using the curve as a central axis. Examples are shown in Figure 3 below.

When designing your own patterns:

1. Create interest by adding a few opposing lines that do not follow the flow of the curve.

2. Don't overdo it! It is easy to add too many fillers. Remember the value of negative space.

3. Remember that odd numbers always look better than even numbers when it comes to leaves, petals, tiny filler flowers, etc. A stem with 3 or 5 leaves is much more interesting than one with 2 or 4 leaves.

4. If your design looks too small or unfinished on the piece, consider the addition of a border design. A border design can be as simple as a single gold line or as elaborate as a string of intertwined flowers. Borders can complement your main design without drawing attention away from it.

If you are confident and wish to draw your design straight onto the piece, use a chalk pencil. Draw the curved line where you want your design. Next, draw the main large flowers in place, and then add smaller flowers and fillers. If you wish to use a pattern, trace the design onto tracing paper, then position it onto the piece. Fasten it in place with a couple of pieces of tape on one side. Carefully lift the side of the tracing paper that is not fastened and slide a piece of graphite or chalk paper underneath. Be sure you have the chalked side of the paper facing downwards. Using either a stylus or an empty ball point pen, trace over the design to transfer it onto the piece.

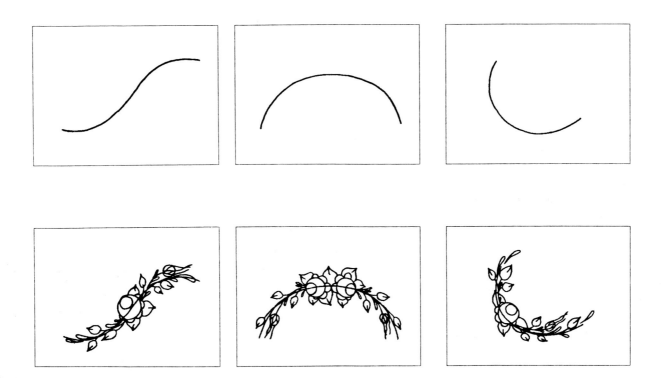

Figure 3. Using a simple curve as the basis for design

Chapter 4
SUPPLIES AND THEIR CARE

BRUSHES

The brush is probably the single most important item you will need. As this technique depends solely on one brush, it needs to be of exceptional quality. I often smile when I recall the first time I demonstrated for my chapter at a large art and craft show in Florida. I had only recently moved to Florida from Australia and had volunteered, along with other painters, to demonstrate for the public on the chapter booth to promote decorative painting. The other girls thought it was quite amazing to see someone whose entire brush collection consisted of two size 3 round brushes.

Because I use only one brush, which takes a lot of abuse, it really needs to be cared for properly. Frequently I load paint right up into the ferrule and push the brush against its bristles. As a result, I need to rinse out the brush frequently during painting. Probably *every 15 minutes* or so, I tap the brush against the inside of the water container to shake paint out of the ferrule and to rinse the bristles. I clean it thoroughly with brush cleaner about every two hours and *always* after I've finished painting for the day. Never leave your brush in the water container as this will bend the bristles. If this does happen, dip the brush into very hot water for a few seconds and repeat until the true shape is restored. The Royal Brush Co. has produced a beautiful brush that is especially suited to my technique. It is a high quality sable with good spring-back characteristics and the bristles are a little shorter than the regular size 3 brush. Ask for "Melinda's Magic Brush" from Royal.

PAINT

With respect to paint, the strong colors and creamy consistency of Deco-Art Americana, Accent, and Jo-Sonja acrylics are perfect for this technique. Their true pigment colors make them especially suited to multi-loading. Other paints with muted colors and thin consistency tend to "mud" in the brush, thereby defeating the whole purpose of the multi-load.

The Plaid Pure Pigment range also gives a pleasing result, although they are somewhat transparent. However, this feature can be used to advantage and will appear as shading on dark backgrounds. The colors are excellent, except for green which can be easily mixed with a little yellow and black to produce a better color.

OTHER ITEMS

Another item I like to use is the Masterson's No. 857 STA-WET Palette. As I use such a limited color range, the small size of this palette is very convenient and comfortable to use. I've kept paint moist and usable for weeks without the need for replacement. When I do need to change the palette, I simply rinse off the paper and use it over and over again. A few helpful hints concerning the palette:

1. Remember when you purchase the palette that it comes with several sheets of *oil* palette paper as well as several sheets of *acrylic* palette paper. The paper for use with oil paints is thin, almost like tracing paper, and can be used for that purpose if you wish. On several occasions I have had a student complain about the paper not performing properly, only to discover that they were using the wrong type.

2. Always use purified water in your palette and for soaking the palette paper. This will prevent it from becoming smelly after a few days as can happen if you use straight tap water.

3. Cover your palette if you leave your painting for more than a few minutes. This will help prevent it from drying out, especially if you are in an air conditioned room.

The only other necessity is a water container, and this can be as simple as a small jam jar. I seldom use the fancy brush basins with all the special features, although I have nothing against them. With my technique, it is not necessary to change the water at all; sometimes I will use the same water for days, and so I don't need to have a division in the container to keep part of the water clean. I also never pull my brush along the ridges on the bottom of the brush basins. This, I have found, can cut the hairs off at the ferrule, especially with a sable brush.

LIST OF SUPPLIES

The Brush. Only one round brush is used. Choose from:

Kolinsky Sable
"Melinda's Magic Brush" by Royal
Scharff 3000 Fine Line, size 2
Habico Kolinsky Standard 110, size 3 or 4

Synthetic and Sable Blends
Yasutomo Detail Master Size 3 or 4
Maureen McNaughton Size 4
Loew-Cornell Mixtique Size 3
Langnickel Combo Size 3

Other supplies. You will also need:

a large flat brush for basecoating and
 varnishing
a jar or water basin
a STA-WET Palette (Mastersons 857)
paper towels
graphite paper, light and dark
graphite pencil, light and dark

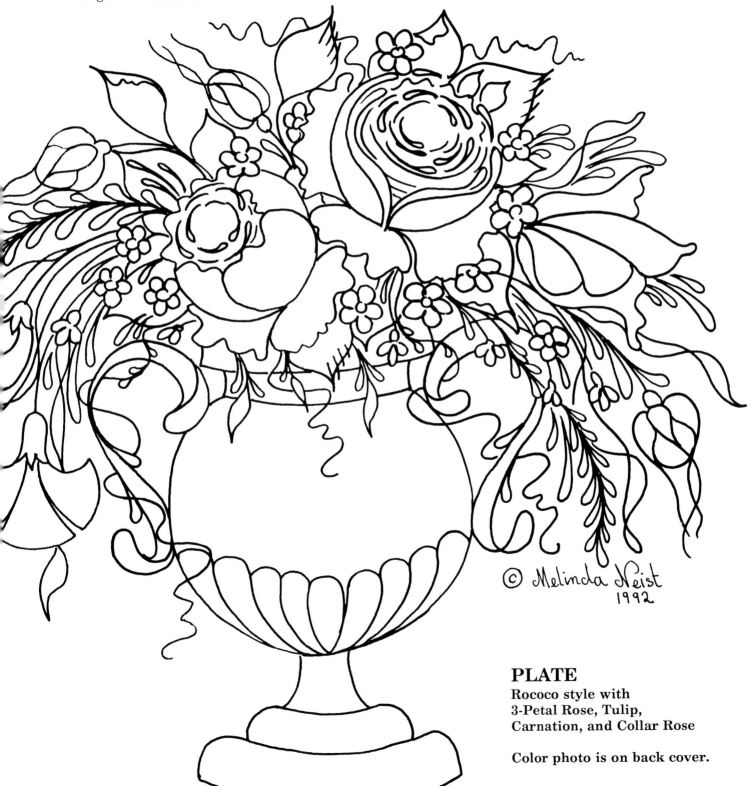

© Melinda Neist
1992

PLATE
Rococo style with
3-Petal Rose, Tulip,
Carnation, and Collar Rose

Color photo is on back cover.

Chapter 5
THE THIRTEEN STROKES

I now take pleasure in introducing to you the thirteen strokes required to master this art form. I cannot stress strongly enough the importance of these strokes. Try to imagine that the thirteen strokes are like the twenty six letters of the alphabet, and that the flowers are the created words. Just like some letters are not always apparent in the spoken word, so, too, the strokes are not always obvious in a painted flower. Learning to paint this technique is like learning to read and write. It will take time and effort on your behalf and, be sure, you'll make a few "spelling mistakes" before perfecting this style of painting.

The strokes must be perfected and I urge you to practice at every opportunity. Even painting the strokes on an old newspaper or scrap paper whilst talking on the phone is good practice and remember, practice makes perfect!

While painting, your wrist and forearm should be supported on the table at all times. *Never* try to paint these strokes with your wrist or arm unsupported. Balancing on your little finger should only be attempted when working in an awkward position, or when trying to avoid smearing previous work. Therefore, it is a good idea to practice the strokes with your wrist and forearm down on the table to become familiar and comfortable with this position if it is awkward or unfamiliar to you.

One of the most important lessons that must be learned when painting the thirteen strokes is: Always be sure to allow the brush to open fully by "dumping" the brush (pressing it down), almost to the ferrule (the heel), before lifting and pulling through the stroke.

The photos accompanying each stroke give you an idea of the progression of the stroke. The strokes were made with a single color of paint so as to be most clear. A color worksheet, showing the completed stroke made with a Basic Triple Load (explained in Chapter 6) is on page 23.

STROKE #1

Dump the brush down on a 45° angle with the tip pointing towards the *left side*. If necessary, wait a second or two to allow the bristles to open (if they don't open, you haven't enough paint in the brush). Now lift up and pull down on the knife edge by pinching the brush into the palm of the hand. *Do not turn the brush!*

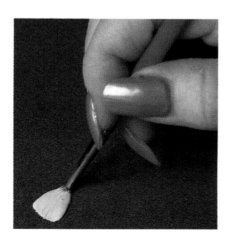 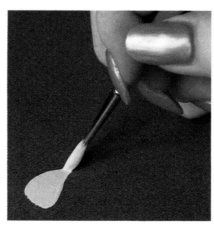 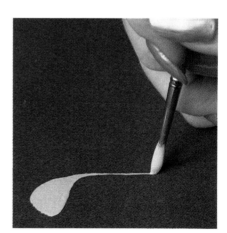

STROKE #2

Dump the brush down on a 45° angle with the tip pointing towards the *right side*. If necessary, wait a second or two to allow the bristles to open (if they don't open, you haven't enough paint in the brush). Now lift up and pull down on the knife edge by pinching the brush into the palm of the hand. *Do not turn the brush!*

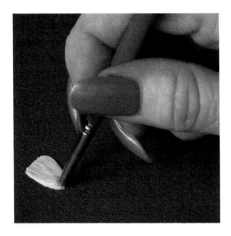
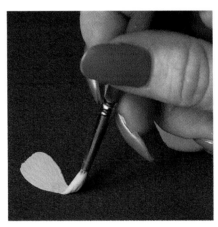
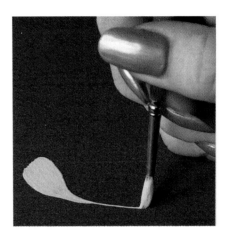

STROKE #3

Dump the brush as for #1 and #2, however, have the bristles pointing straight up instead of on an angle. Whilst lifting up and pulling the tail downwards, turn the brush 1/4 turn to enable it to pull down on the knife edge. Try to lift, turn, and pull down all at the same speed.

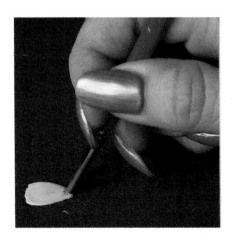
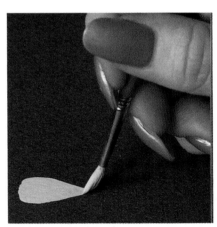
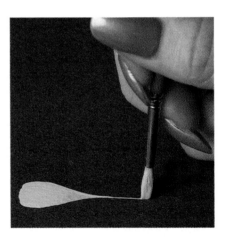

A NOTE REGARDING THE STEP-BY-STEP PHOTOS

So that you can easily follow the directions for each of the thirteen strokes, consider that you are looking over my left shoulder as I demonstrate them in the photos. The top edge of my paper is at the *left* side of the photos. I am pulling strokes down toward the bottom of the paper, which is at the *right* side of the photos.

STROKE #4

Touch the tip of the brush down, then, as if changing your mind, lift the brush. Pull away from the dot, slightly towards the right, allowing a thin bridge of paint to remain between the tip and the paper. Dump the brush down on a 45° angle, exactly as you did in Stroke #1, however, this time push the bristles to open towards the top of the page by exerting pressure on the tip of the brush. Follow through by lifting and pulling the tail downwards exactly as for Stroke #1 without turning the brush.

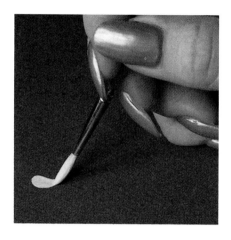 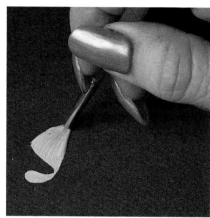 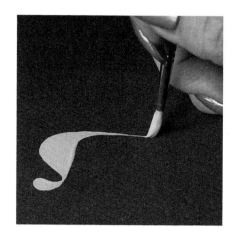

STROKE #5

Touch the tip of the brush down, then, as if changing your mind, lift the brush. Pull away from the dot, slightly towards the left, allowing a thin bridge of paint to remain between the tip and the paper. Dump the brush down on a 45° angle, exactly as you did in Stroke #2, however, this time push the bristles to open towards the top of the page by exerting pressure on the tip of the brush. Follow through by lifting and pulling the tail downwards exactly as for Stroke #2 without turning the brush.

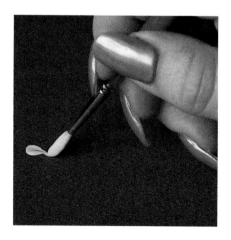 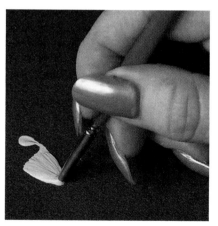 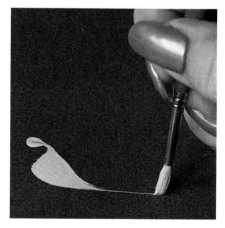

STROKE #6 (A little difficult)

Touch the tip of the brush down, then, as if changing your mind, lift the brush. Pull away from the dot, slightly towards the right, allowing a thin bridge of paint to remain between the tip and the paper. Dump the brush down on a 45° angle, exactly as you did in Stroke #1, however, this time incline the bristles to open towards the bottom of the page, forming a bulge. Follow through by lifting and pulling the tail downwards exactly as for Stroke #1 without turning the brush.

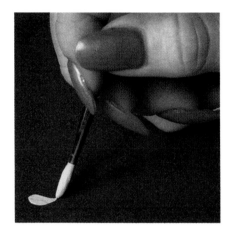 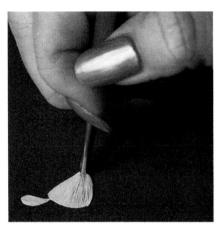 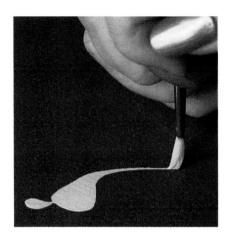

STROKE #7 (The most difficult stroke. Everybody hates this one.)

Touch the tip of the brush down, then, as if changing your mind, lift the brush. Pull away from the dot, slightly towards the left, allowing a thin bridge of paint to remain between the tip and the paper. Dump the brush down on a 45° angle, exactly as you did in Stroke #2, however, this time incline the bristles to open towards the bottom of the page, forming a bulge. Follow through by lifting and pulling the tail downwards exactly as for Stroke #2 without turning the brush.

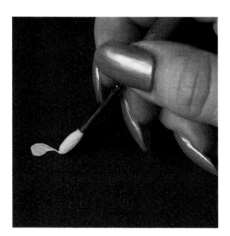 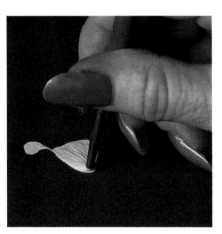 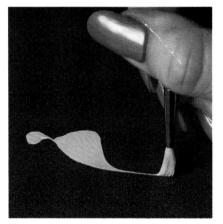

STROKE #8

Touch the tip down and lift up again as if changing your mind. Pull downwards, away from the dot, allowing a thin bridge of paint to remain between the tip and the paper. Dump the brush, allowing the bristles to open evenly to each side then lift and pull down whilst turning the brush 1/4 turn allowing it to pull the tail downwards on the knife edge. This stroke resembles Stroke #3 except for the little blob on the top.

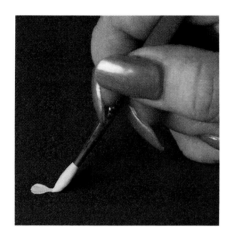 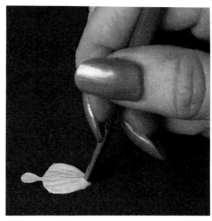 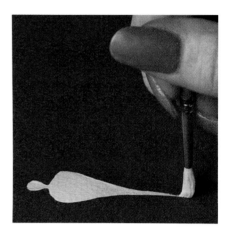

STROKE #9

This stroke is executed exactly like Stroke #8 but instead of allowing the bristles to open evenly to each side, incline them to open only to the left by exerting pressure on the tip of the brush, leaving a perfect straight edge on the right side.

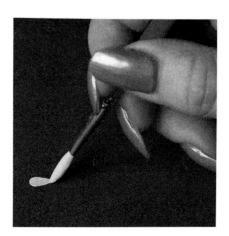 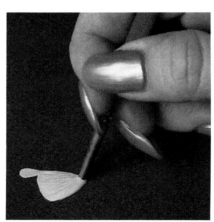 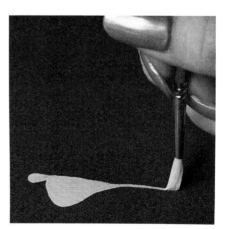

STROKE #10

This stroke is executed exactly like Stroke #8 but instead of allowing the bristles to open evenly to each side, incline them to open only to the right by exerting pressure on the tip of the brush, leaving a perfect straight edge on the left side.

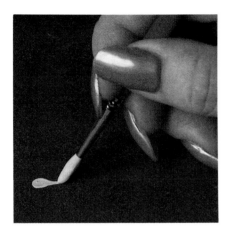 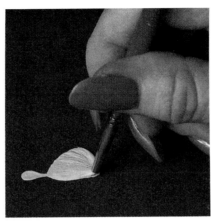 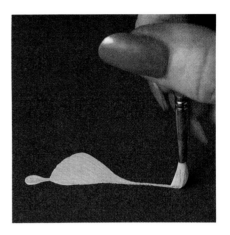

STROKES #11 & #12 (Round "C" Strokes.)

Exert only very light pressure to begin the stroke, pushing down and opening the brush as you come around to the center of the stroke, then lifting up to complete the stroke with very light pressure. *Do not turn the brush.*

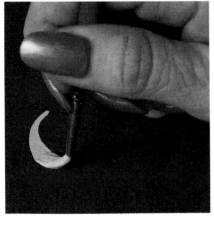 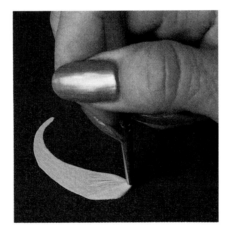 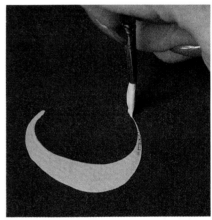

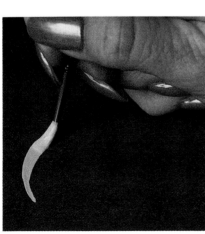 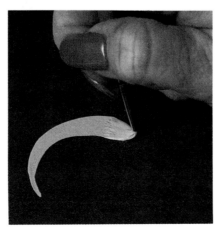 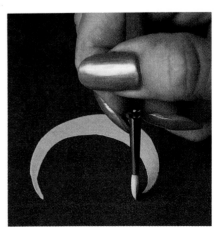

STROKE #13

Dump the brush down horizontally and open the brush, inclining the bristles to open only to the top by exerting pressure on the tip of the brush. Without stopping, lift up to the tip and moving from left to right, dump the brush down again, inclining the bristles to open to the top only. Lift up to the tip and dump down once again. Repeat as often as you wish, continuing in one long line. The underside of the stroke should be straight while the top should resemble a row of mountains. Left handers should work from right to left with this stroke.

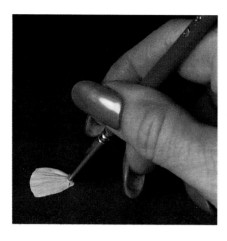
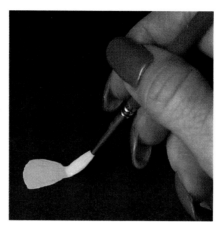
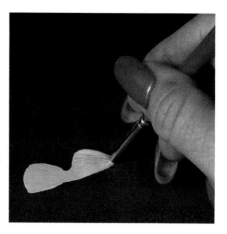

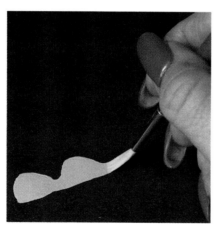
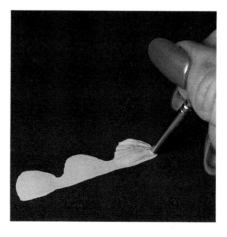

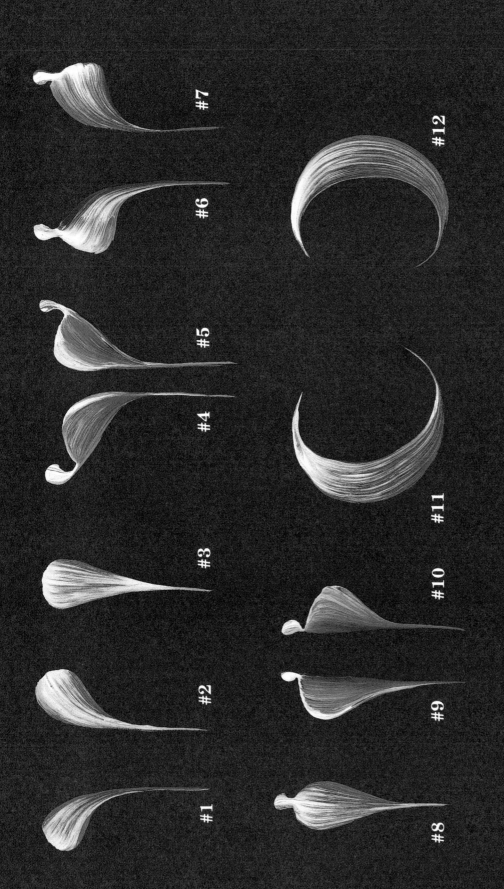
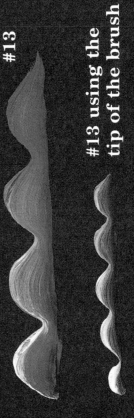

#7

#6

#5

#4

#3

#2

#1

#12

#11

#10

#9

#8

#13

#13 using the tip of the brush

THE 13 BASIC STROKES

Practice!

Practice!

Practice!

GREEN TRAY
Pattern
on page 37

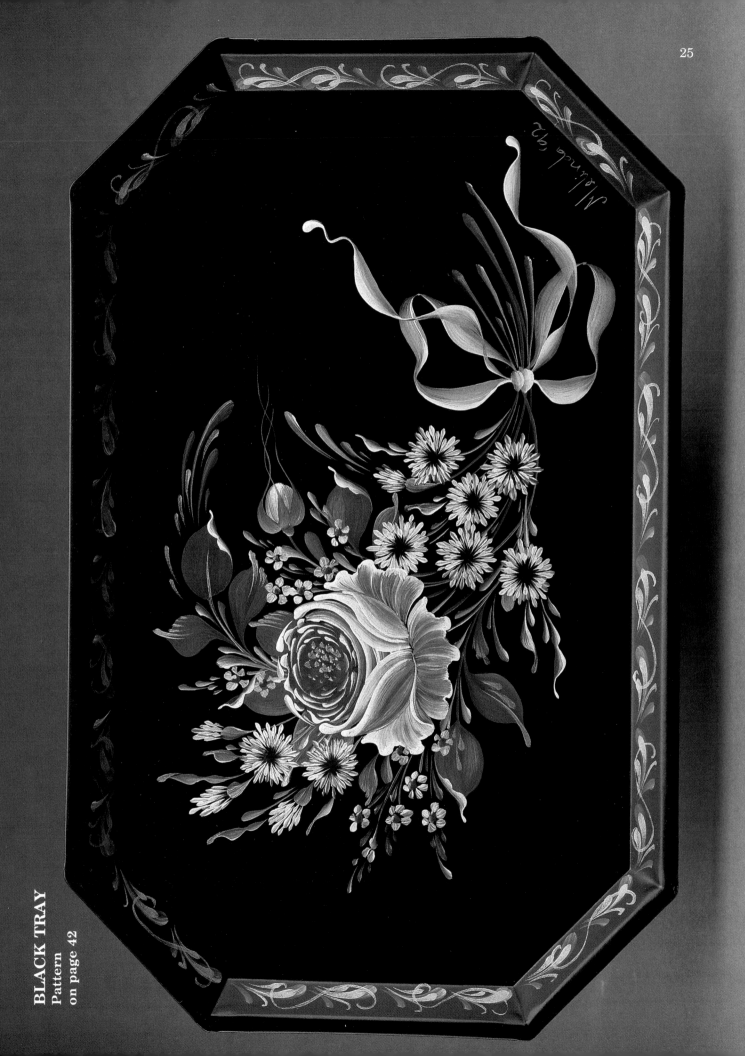

BLACK TRAY
Pattern
on page 42

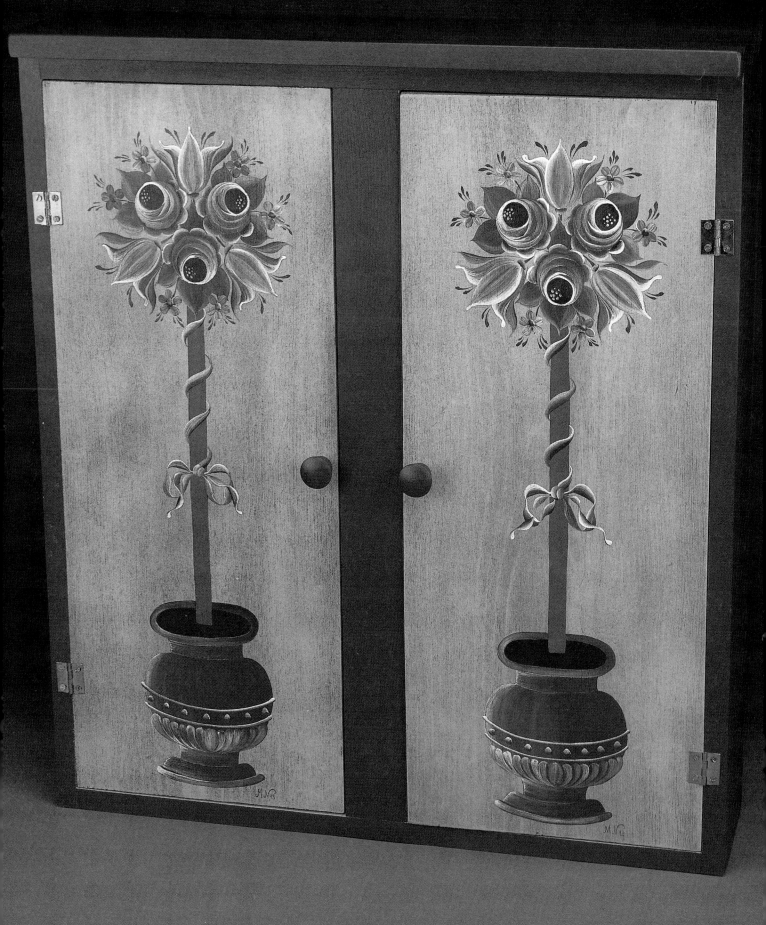

Chapter 6
BAROQUE FLOWERS AND FOLIAGE

FOLIAGE (Worksheet on page 30)

Leaves may be painted in many colors. Blues, teals, black, and even red can be very interesting on a multitude of colored backgrounds. I have included a Background Color Chart on page 45 which provides many variations of foliage color for differing backgrounds. In these instructions I have chosen to use only Avocado (green), Lemon Yellow (yellow), and Snow White (white) for foliage on color worksheets. I feel this should make my instructions seem less complicated during the learning stages. When the techniques have been mastered and you are painting on your chosen pieces, you may use foliage colors of your choice by referring to the Background Color Chart.

Fully load your brush almost up to the ferrule with green. As you load, flatten the brush to a "knife edge." *Don't roll the brush in the paint, causing a round point.* A little white may now be pushed into one side of the brush. Pick up a little white and push down on the palette to slightly blend it into the green. Dark background leaves may be left solid green by leaving out the white or you can mix a little Ebony Black into the green to make them darker still.

Using one or two strokes, depending on leaf size, start at the point of the leaf and "cut" with the "knife" edge. As you start to pull down, open the brush out to the desired width, then pick up slowly as you meet the stem, allowing the bristles to spring back to a knife edge. For leaves which are behind the flowers, and are thus painted first, simply open the brush as described and pull onto the flower without worrying about painting over the tracing lines. The flowers are painted later.

Once the large and medium size flowers are painted and the design is almost complete, reload to a knife edge in the green. Pull out a little white, or white and yellow mixed, on one flat side of the brush, pushing it into the brush slightly as you do this. Cut in the stems and small comma stroke leaves, picking up a little extra white or green when necessary. Return the brush to the palette to reinforce the flat knife edge as needed. When painting the main stem of a flower, exert more pressure on the brush to make it thicker toward the lowest part of the stem and pick straight up quickly to give a blunt, cut-off look to the end. Cut in small, sharp, comma stroke leaves as needed, especially where large leaves may appear a little heavy. Mix a little yellow with

THE BASIC TRIPLE LOAD (Used for most flowers)

Load the brush fully, almost up to the ferrule with Napthol Red. Touch the tip to the green. Come back to the red puddle and blend these together to make a reddish, burnt sienna color. I will refer to this color from now on as **Broken Red**. With Broken Red in the brush, pull through Antique Gold Deep on one side. The brush should flatten against the palette as you pull the gold out of the puddle. Pick up white on the gold side of the brush. To do this correctly, lay the gold side of the brush on top of the puddle of white and lift it away. The white should appear as a fingernail on the brush. This is referred to as the Basic Triple Load and is used when a reddish or pink shade is required for a flower.

Other pre-mixed colors may be used instead of Broken Red including Burgundy Wine, Country Red, Georgia Clay, and other reddish colors. Pure reds may also be broken with other dark colors such as any dark blues or black. However,

Antique Gold Deep

White

Broken Red

in these instructions I have provided the most traditional and basic formula for burnt sienna (i.e. Broken Red with green).

The Antique Gold Deep referred to and used throughout this book is from "Enid's Collection" Americana by Deco-Art and is **not** the Antique Gold from the regular Americana range. This greenish-gold color is used only as a buffer and is not applied heavily to the brush. Its purpose is to prevent the red mixing into the white and producing a boring pink mud. This is a magic color and will be used frequently. If it is unavailable in your area, it can be easily mixed by following the instructions on page 47.

white. Load the brush and bring it to a sharp knife edge as you pull through the paint. Now, referring to the colour worksheet, cut in some small sharp comma strokes to add a little detail to each leaf. Paint each a little differently for interest. (Small "filler" flowers would now be added once all foliage is completed.)

For tulip and carnation leaves, load with green and pick up white or a mix of yellow and white. As you pull the long, ribbon-like leaf down toward the stem, flip the brush from side to side to give the impression of twists in the leaf. Lift the brush almost off the surface as you flip it over to produce the thin leaf edge. The white side of the brush faces upwards as it flips over.

THE TOLZER ROSE (Worksheet on page 30)

Although being naive and simple in appearance, and perhaps the least popular of the Baroque flowers, the Tolzer Rose teaches the basics of color loading and brush control. You may also discover, as we progress through this book, that it is possibly the most difficult of flowers, as it requires far more precise placement of the strokes than other more open flowers.

With the Basic Triple Load (see page 27) in the brush and starting at the top of a circle, face the white side of the brush to 1 o'clock. Gently touch down and continue around, forming a #11 stroke. Continue the circle in the air as you come around and touch the brush down a little lower than where the first stroke started. Form another #11 stroke. Continue the circle around in the air and proceed with a third #11 stroke a little lower again. The left side of the rose is now complete. (You should not need to replace paint on the brush between strokes, unless painting a particularly large flower, or practicing on paper or cardboard which will draw moisture from the brush.)

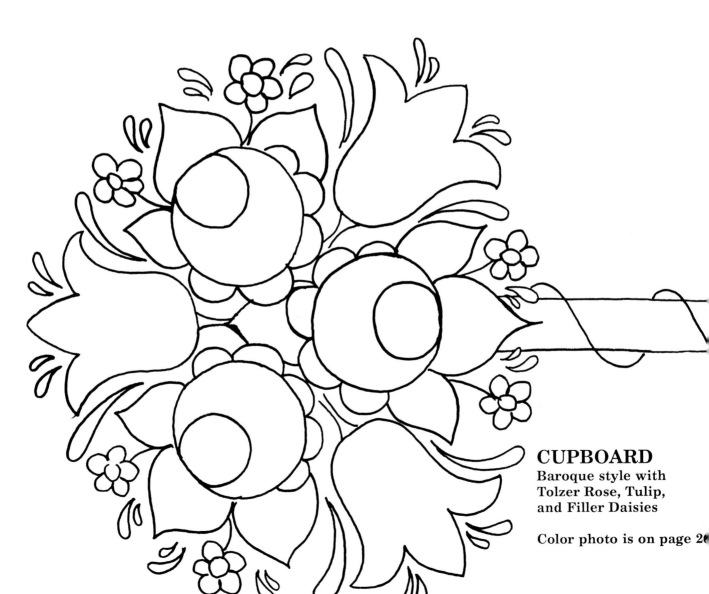

CUPBOARD
Baroque style with Tolzer Rose, Tulip, and Filler Daisies

Color photo is on page 2(

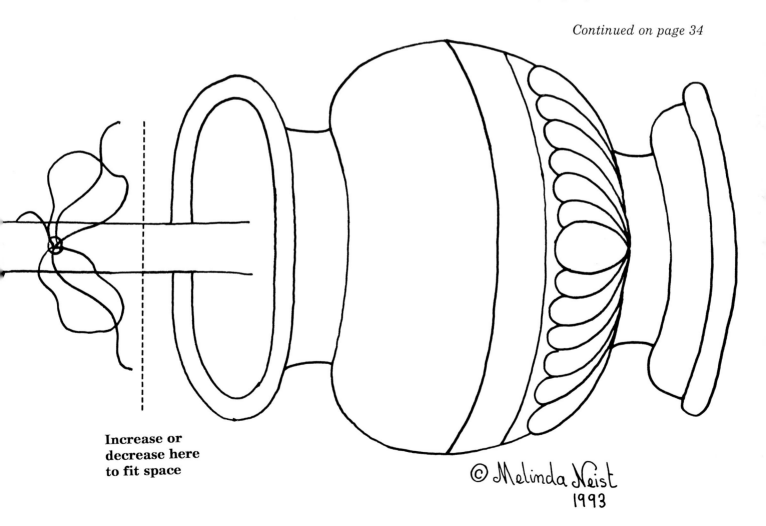

Wipe what remains of the white off the brush, and, without washing it, go straight to the Broken Red and proceed to replace the Basic Triple Load as before. (The white is removed before returning to the Broken Red so as not to cause a muddy pink in the brush **or** the puddle of paint.) Face the white side of the brush to 11 o'clock and proceed as described above except this time form the right side of the rose using three #12 strokes.

Now for the skirt! Remove the white as before. Replace the Basic Triple Load in the brush. Turn the design upside down. With the white side of the brush facing away from the base of the flower, push and lift, moving left to right around the base of the rose bowl. This is, of course, the #13 stroke. Did you recognize it? Wipe any remaining white from the brush, reload Broken Red and, using three strokes, fill in the darker center of the rose, rounding it out if necessary.

THE TULIP (Worksheet on page 31)

The tulip is one of the flowers that are seen in every era of folk art. The simplest, naive tulips were very prominent in the Baroque Era, and they became prettier as styles developed. Tulips can be painted in a variety of colors and are one of the easiest flowers to paint.

We will use the same triple loading technique once again. However, this time the sequence will be different while the colors are the same as for the rose. Load the brush quite full with Antique Gold Deep, pull through the Broken Red, and pick up Snow White on the gold side of the brush. Facing the white side of the brush to the top and starting with the right side petal, gently touch down dragging the brush towards the center of the flower and then downwards whilst pressing down to allow the brush to open fully. Lift the brush up as you cut inwards towards the center again, this time at the base of the flower. (Be sure to *open* the brush fully by slowing the stroke when painting tulips.)

Replace the white on the same side of the brush as it was originally placed. Repeat this stroke again on the left side of the flower reversing the direction. Now, pull two strokes down from tip to stem to form the center petal. Keep the white side of the brush facing slightly outwards to form

Continued on page 34

Increase or decrease here to fit space

© Melinda Neist
1993

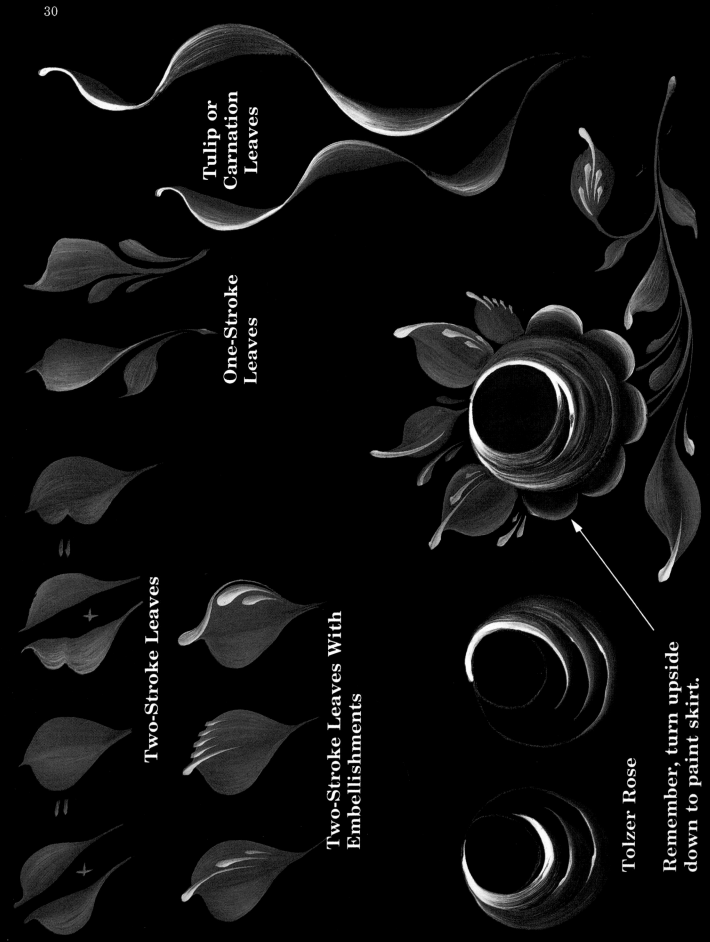

Tulip or Carnation Leaves

One-Stroke Leaves

Two-Stroke Leaves

Two-Stroke Leaves With Embellishments

Tolzer Rose

Remember, turn upside down to paint skirt.

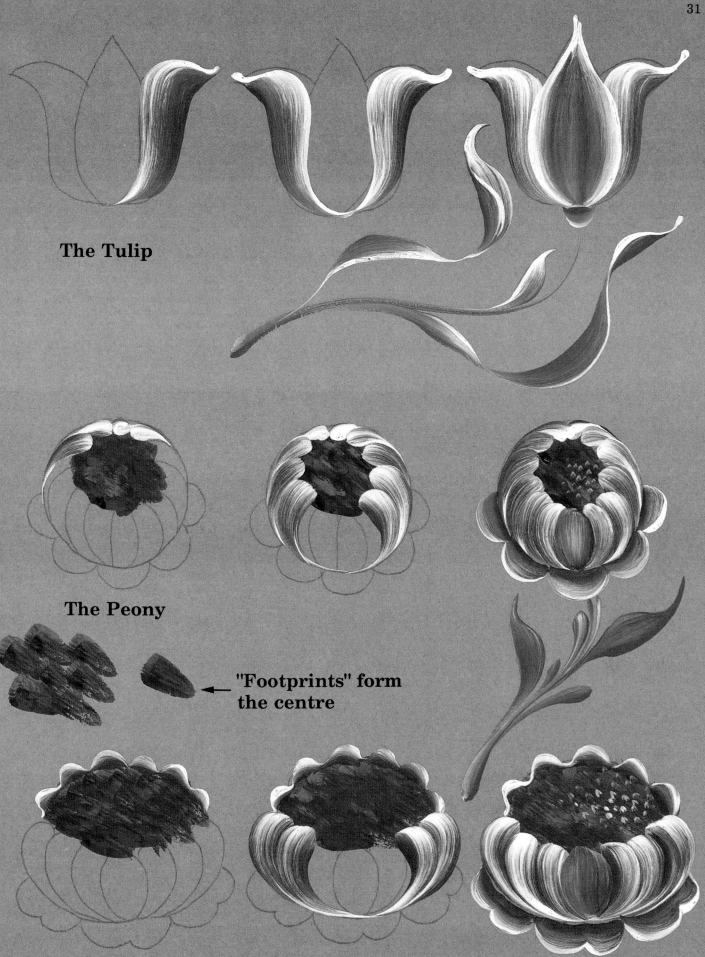

The Tulip

The Peony

"Footprints" form
the centre

The Rosebud

Carnations

Filler Daisies

Cornflower

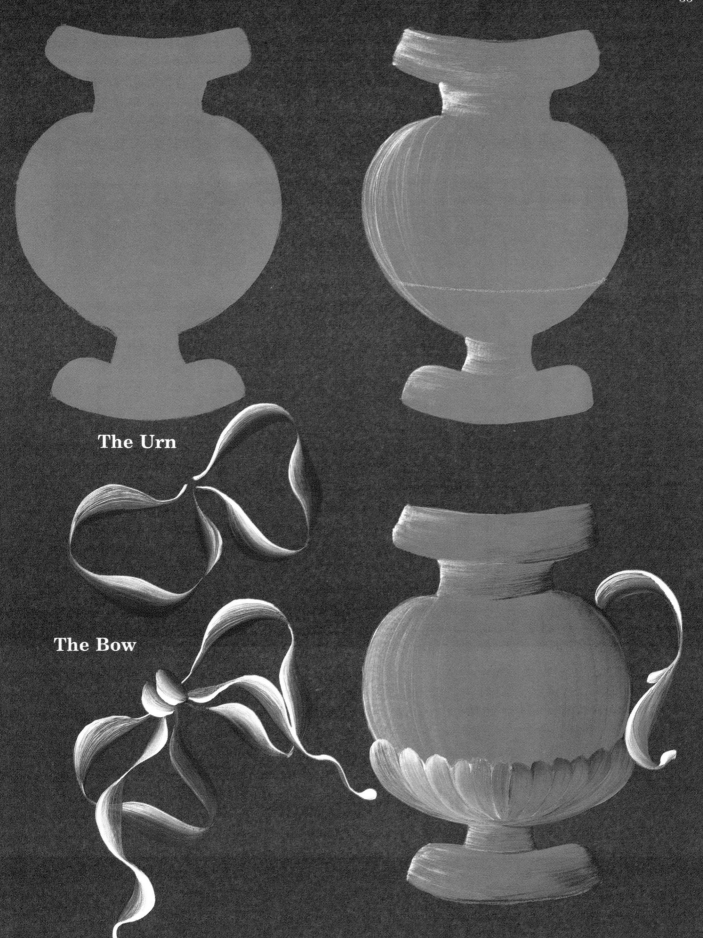

The Urn

The Bow

a white ridge defining the shape of the center petal. These are variations of strokes #9 and #10. If a line or slight gap is left in the center, simply sweep the brush downwards again from tip to stem using very gentle pressure. A simple double load can also be effective for the tulip, i.e. load Sapphire (blue) and pick up white.

THE PEONY (Worksheet on page 31)

Here is another flower that is seen in all eras of folk art. The peony may be painted in a very stylized and naive form in Baroque design. Or, it may be painted far more soft and delicate with frilly skirts and turned petals, as seen in later styles.

For the center of the flower, load the brush with Broken Red. Pick up Avocado Green mixed with Ebony Black on one side and Antique Gold Deep on the other. With the green side of the brush facing downwards, towards the bottom of the flower and the gold facing towards the top of the flower, fill the center by pressing down on the brush, then lifting straight up, creating a series of "footprints." Move from the bottom towards the top of the flower in a curved direction and move back into the center to fill any gaps (see color worksheet).

Return the brush to the Broken Red, pull through the gold and pick up white on the gold side (the Basic Triple Load). Proceed to paint the petals as follows. Start at the center top with the white side of the brush facing the ceiling. Gently touch the tip of the brush down forming a few tiny #1 strokes, working towards the right of the flower. The first one or two of these strokes should appear only as little blobs. Now repeat this procedure on the left side of the top of the flower, using #2 strokes. Work from one side to the other, increasing the length of the strokes as you come around to the front of the flower. Pick up white on the same side as before when you need it. This could be every first, second, or third stroke depending on the size of the flower.

As you come to the center front of the flower, notice how the strokes need to be a little straighter with the center stroke which is last, being a #3 stroke (straight) without the long tail. For this last stroke, turn the white side of the brush downwards to face the surface. This is done so that the white highlight will show up in the center of the stroke instead of at the top. This will give a rounded appearance to the front of the flower. The skirt is accomplished in exactly the same manner as described previously for the Tolzer Rose, but

remember to turn the design upside down when doing so.

Another version of the peony, having a more open appearance, is painted in a similar manner except for the top. Instead of tiny #1 and #2 strokes, the #13 stroke is used across the top of the flower, representing the tips of the back petals peeping over the center, from behind. However, the whole brush is not dumped down as when practicing the #13 stroke. Instead, only the top half of the brush is used in forming the stroke, being sure to lift up to the absolute tip between the "mountains." Even lifting off the surface can be acceptable.

A double skirt may be used on either version of the peony. Turn the flower upside down, as before, and proceed as if painting the previously described #13 stroke skirt. However, this time, when the brush has been dumped down and you begin to lift up to the tip, change your mind half-way and dump down again forming a "double mountain," then, lift to the tip and continue in this manner to complete the skirt. With the remaining paint on the brush, touch the tip down several times in the center of the flower, but slightly to one side, to form the tips of tiny stamens.

THE BUD (Worksheet on page 32)

Using whatever paint is left on the brush after finishing a flower, pull down one or two short strokes toward the stem. Clean the brush and reload with green. Push a little white into the brush as mentioned before, in the paragraph on leaves, then at the base of the bud make a small comma stroke. Now pull three comma strokes from the base to beyond the tip of the bud, curling them as you go. Paint the two outside commas first and the center one last. An important point to note when painting buds is when painting the green comma strokes, be sure the brush has lifted up onto its tip before it leaves the bud area, then drag the long tendrils out and away from the bud (see colour worksheet). The strokes used here are variations of the #1, #2, and #3 strokes.

THE CARNATION (Worksheet on page 32)

A simple and very stylized flower, when it appears in Baroque designs, the carnation uses #1, #2, and #3 strokes in their original form. This flower may be painted in many different shapes, sizes, and color combinations. It is not necessary to describe the steps in detail, as for previous flowers, because by studying the color worksheet you will easily understand the techniques used.

The Basic Triple Load using either Broken Red or Antique Gold Deep as the main color in the brush can be used for the carnation. Double loads, such as Navy Blue and Snow White, Sapphire (blue) and Snow White, or Antique Gold Deep and Snow White, can also be used. The white side of the brush faces the ceiling whilst painting the strokes. Replace white to the brush as necessary throughout painting the flower. A small, longish tulip-shaped base is added to the carnation using green with a little white pushed into the brush.

"FILLER" DAISIES (Worksheet on page 32)

These simple little daisies may be added to your patterns whenever a little color needs to be carried through to another section of the design. They can also fill an area where a larger flower would be too much and throw the design off balance. They can be painted in a multitude of color variations.

Load the brush with Sapphire (blue) and pick up Snow White. Keeping the white either to the top or the underneath, pull in five or so short strokes. Allow the bristles to open slightly before pulling the brush up. Be careful not to get the "pinwheel" effect. For daisy centers, clean the brush, load with Broken Red and pick up either Antique Gold Deep or Lemon Yellow on one side of the brush tip. Touch the tip down with the yellow side facing one o'clock and push slightly towards one o'clock. (Imagine the daisy is a clock face when doing this.) This will make a good rounded center with a highlight for your daisy. Daisies may also be painted by cutting the stroke in on the knife edge, to form more narrow petals. Cornflowers are painted in this manner.

THE CORNFLOWER (Worksheet on page 32)

When painting a cornflower, first lay down a blob of Ultra Blue Deep. Quickly clean the brush and reload to a knife edge in Snow White. Cut fine straight strokes into the blue blob whilst it is still wet. As the brush loses its knife edge (about every 3 or 4 strokes), return it to the palette and reinforce the knife edge whilst loading up fresh white paint. Work around the flower again with shorter, whiter strokes to give a fuller appearance.

THE BOW (Worksheet on page 33)

Load with Broken Red, pull through Antique Gold Deep and pick up Snow White on the gold side. Proceed to paint the bow in exactly the same manner used for the tulip or carnation leaf. Two short curved strokes form the knot.

THE URN (Worksheet on page 33)

Urns were used during all eras of folk art and may be quite simple or elaborate with over-stroking, drapes, and other embellishment. Base coat the entire shape with two coats of Antique Gold Deep. Do not base coat the handles as these are applied last of all with a double loaded stroke. Proceed as described below, one section at a time (the rim and neck first, then the body of the urn, and finally the base).

Wet half the area by applying a generous coat of Deco-Art's Control Medium or an extender of your own choice. I like to use Deco-Art's Control Medium as it is quite thick. Pinch wipe the brush with a paper towel, as this forms a sharp, stiff knife edge. Carefully dip this edge into Snow White, pick up only a small amount, and tap it down along the edge of the urn forming a thin white ridge. Pinch wipe the brush again and proceed to pull the white from the ridge, using very gentle pressure, allowing it to blend out to nothing by the time your brush has reached the center of the urn. Be careful to follow the contour of the curved shape of the section on which you are working. This horizontal style of highlighting is used for short wide sections, such as the rim or the stand of the urn.

Large, tall sections are highlighted by applying the control medium to half the area, as previously described, and then side loading the brush into the white. Proceed to stroke downwards, starting at the outer edge and "walking" the brush towards the center. Allow the white to blend out to nothing before reaching the center of the section you are working on. Note that on the color worksheet the horizontal highlighting is shown on the rim, neck, and base of the urn. The vertical highlighting technique has been used on the main body section. Shading is done using exactly the same procedure and using a dark broken red color.

If your urn has narrow, curved handles, load the brush with Antique Gold Deep and pick up Snow White on the other side. Paint the handle in one smooth stroke, keeping the white facing the top of the design and flipping the brush as necessary in order to keep the white uppermost. This is not unlike the technique used to paint the tulip leaf or bow. A little extra white may be picked up on the brush and a small comma added to the ends of the handle to neaten as necessary. When over-stroking is applied, start from the outer edges and work inwards picking up either the highlight or shading color on the brush, which has already been loaded with Antique Gold Deep.

Chapter 7
ROCOCO FLOWERS & FOLIAGE

FOLIAGE

Rococo Foliage is painted in the same manner as was used earlier when painting Baroque. However, the designs appear far more interesting, as you are no longer confined to symmetry. The addition of turned leaves, vines, ferns and ruffled edge foliage also add interest and elegance to the Rococo Design. Colors used in these instructions are Avocado (green), Antique Gold Deep (gold), Lemon Yellow (yellow), and Snow White (white).

THE TURNED LEAF (Worksheet on page 39)

Load the brush fully (but not globby) with green and bring it to a sharp knife edge. Pick up white, or a mix of yellow and white on one flat side of the brush. Once again, don't glob it on. For turns on leaves, you need to load sparingly so as not to lose the flat knife edge of the brush. Choose leaves which have a straight side or flat edge and add your turns there. With gentle pressure and precise placement, cut down onto the edge of the leaf with the white side of the brush facing the inside of the leaf. Carefully move downward, applying and releasing pressure to the tip of the brush. To finish the turn, lift up again, release pressure, and cut the knife edge down along the original edge of the leaf. An important point to note is this—*don't make a career of turned leaves.* Just a couple in a small design is sufficient to add interest, maybe a few extra in a larger design. I know they look wonderful and are fun to paint, but don't be tempted to overdo it, as this could cause your design to look too "busy."

RUFFLED LEAVES (Worksheet on page 39)

Load the brush with green and pick up white on one side, a little heavier on the white this time. Moving from the top of the leaf downward, let the white "dribble" off the tip of the brush in a slightly random fashion. To do this, gently touch the white "glob" to the surface, shaking slightly and exerting uneven pressure as you "push and lift" moving toward the bottom of the leaf. As you reach the end, apply more pressure to the brush, forcing the bristles to flair. With the white side of the brush facing the ceiling, push into the wet white ridge of paint. Now that you have "grabbed" the white, pull back in a slightly curved motion, similar to a #1 or #2 stroke, depending upon which side of the leaf you are working. This movement will form the

bottom of the leaf and the stem. Touch the brush to a paper towel to remove any excess globs of white and, moving upward, repeat pushing the brush into the white ridge and pulling down as many times as necessary to complete the leaf. A nice turned edge can add interest to this type of leaf when applied to the straight side. Once again, don't use too many of these elaborate leaves in one design.

THE VEINED ROSE LEAF (Worksheet on page 39)

These leaves are very elegant and should not be used in early Rococo designs. They are seldom seen even in later Rococo designs and, therefore, should be used *only* occasionally and *only* with the more elaborate roses.

Load the brush with green and pull through white, or white and yellow mixed, or pull through gold and then pull through white on the gold side. Any of these three combinations will give a pleasing result. Choose an already painted leaf and using the sharp knife edge of your loaded brush, gently pull a central vein from the stem almost to the top of the leaf. Turn the white side of the brush downward, toward the surface and, starting at the base of the leaf, pull several #1 (or #2 strokes, depending on which side of the leaf you are working) from the center outward. You may want to only vein one side of the leaf or perhaps pull through less white, or even no white for the opposite side—the choice is yours. On a dark background you may use this technique to form the entire leaf without using an already painted leaf as a base; however, it is easy to lose your direction altogether by doing this. I would suggest using a base leaf whilst learning this technique.

FERNS AND VINES (Worksheet on page 39)

I feel there is no need to describe the procedure for Ferns and Vines in great detail, as the color worksheet is an explanation in itself. Ferns are simply a series of #1 and #2 strokes using the knife edge of the brush which has been loaded with green and pulled through white (or white mixed with yellow). They are usually painted lighter in shade than the main leaves in a design which is on

a dark background, or they can be painted quite dark on a light background. They can be used to "soften" a design or make a grouping of large flowers and foliage appear more delicate. Vines are often used for the same reasons. They look wonderful twisted around a heavy stem or length of ribbon. Vines are painted using the tip of the brush which has been loaded with slightly diluted paint. The paint should have enough water added to make it a little thicker than ink consistency but not runny.

THE "PULL IN" DAISY (Worksheet on page 39)

These daisies may be either large or small and almost any color. The "Pull In" technique is used frequently in the more elaborate flowers and leaves of the late Rococo and Empire eras. Learning to paint this simple daisy will help prepare you for those more complicated florals. For the small daisy, load the brush with Blueberry and pick up Snow White on one side. Gently push two little hills (#13 stroke) onto the outer tip of one petal using the tip of the brush. (With the white side of the brush facing away from you push *toward* the

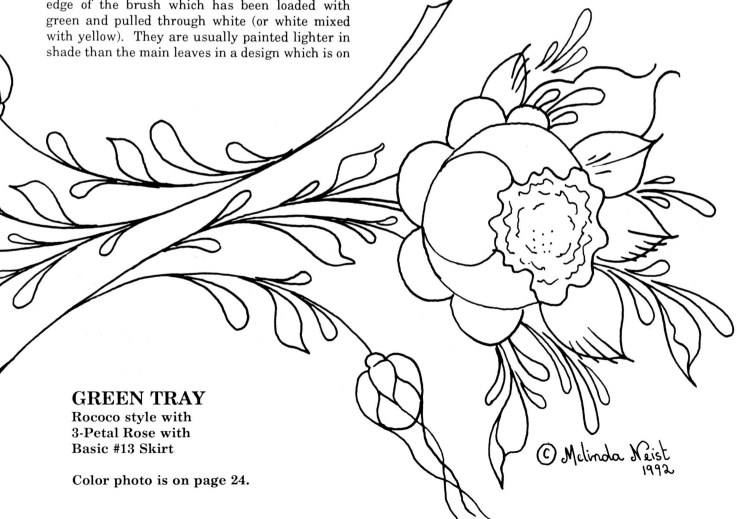

GREEN TRAY
Rococo style with
3-Petal Rose with
Basic #13 Skirt

Color photo is on page 24.

© Melinda Neist
1992

white side as you do this.) Remove the excess white, that is left on the brush, by wiping it on a paper towel.

Return the brush to the petal and with the white side facing the ceiling, touch the tip down just below the white, and push the bristles up into the first of the little white hills. Now that you have "grabbed" the white, pull the brush down toward the center of the daisy. Quickly remove the white from the brush again on the paper towel and repeat the procedure for the second little hill before the white dries. If a ridge of white paint is obvious in the center of the newly formed petal, simply pull down another light stroke to remove it. Repeat this procedure four more times to complete the five petals of the daisy. For the centers of these smaller daisies, use the same technique as indicated for the centers of the "Filler" Daisies described in the previous chapter.

The larger daisy is painted in exactly the same manner; however, three or more little white hills are pushed up for each petal instead of only two. (Be careful not to line them up too evenly as this can look boring.) This will also mean that more strokes will be required to pull the White down and form the petal. The center for larger daisies is more detailed with shading and highlights. Load the brush with Antique Gold Deep and using the tip, "tap" in an oval shape, slightly higher on the top side. Wipe the brush on a paper towel and load a little Dark Broken Red into the tip. Tap shading into the bottom area of the gold oval. Clean the brush, load the tip with gold, and then pull through white on the top of the gold. Tap in the highlight, moving along the top of the oval, coming back around and into the center (see color worksheet for exact placement). Work quickly, as this center looks best when worked "wet into wet."

TULIPS (Worksheet on page 40)

For the blue tulip, fully load the brush with Sapphire (blue), pull through the Broken Red (not much red), and pick up Snow White on the blue side. Starting with the right side petal, dribble a little white to define the top edge. Then, as described previously for the Pull-In Daisy, push the brush up into the white and pull down, starting at the inner side of the petal and working to the outside. Repeat for the left side petal. The center petal may be painted in one of two ways. Reload the brush with blue, pull through Broken Red, and pick up white as before. Now, pull two strokes (#9 and #10) down from the tip to the stem, one on either side of the center petal, fill any gap left in the center by simply sweeping the brush down

again from tip to stem. Be sure to *open* the brush fully and slow the stroke down to allow the bristles to open when painting tulips. If the bristles don't open out as you are painting the stroke, you don't have enough paint in the brush. The second method for painting the center petal is to fill the area with a series of #7 strokes, curving and pulling down into the base of the flower as shown on the colour work sheet. "Flair" the brush downward, slightly, before pulling the stroke away to give a fuller appearance to the petal.

The yellow tulip uses the same methods applied above. However, being more closed in appearance, the first method described for the center petal is more appropriate here. A couple of overstrokes may be applied to the central petal to add interest, if so desired. The loading for the yellow tulip is as follows: Load brush fully with the Antique Gold Deep, pull through Broken Red and pick up Snow White on the gold side.

ROSES

Many different roses were painted during the Rococo and Empire eras. I will describe the procedure for two of the most popular Rococo roses. These instructions will utilize only the Basic Triple Load (Broken Red, Antique Gold Deep, and Snow White) as you will, no doubt by now, be very comfortable and familiar with this sequence. Many color combinations may be used in a triple or four color loading. I will describe several of these in Chapter 8. You will be able to paint your roses in colors that compliment your backgrounds and your decor by changing either the sequence of the brush loading or one or two of the colors.

"COLLAR" ROSE (Worksheet on page 41)

Center. Load the brush with Broken Red and tap the heel or ferrule of the brush into Avocado, then scoop a blob of Antique Gold Deep on the tip. With the green side of the brush facing downwards towards the surface, tap in the center of the rose moving upwards in a fan shape.

Important Point to Note! Never exert a lot of pressure when loading or painting with the ferrule or heel of the brush as it may cut the brush hairs. This action is frequently used for more advanced work within this technique. Sable hairs need special care and will give you long and faithful service if treated with respect.

Continued on page 42

Ruffled
Leaves

Ferns and Vines

Daisy Centre

Turned Leaves

Veined Leaves

Turned
Petal

Pull in Daisy

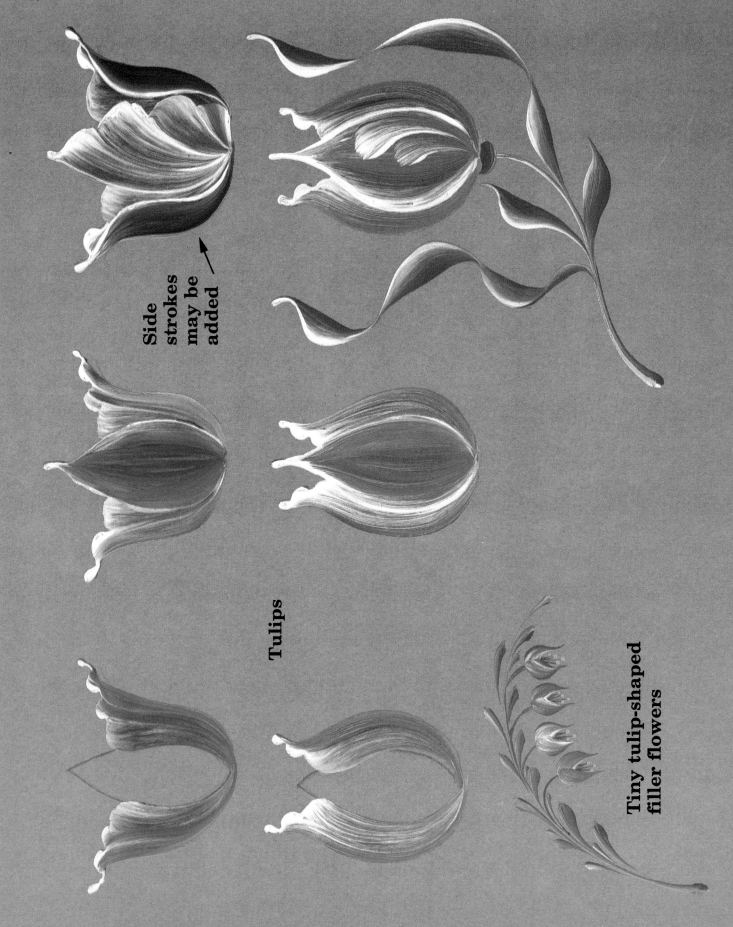

Side strokes may be added

Tulips

Tiny tulip-shaped filler flowers

Collar Rose

Turned Petal

3 Petal Rose

Reload the dirty brush with Broken Red, pull through the gold and pick up Snow White on the gold side. Place small comma strokes around the top of the rose center, moving left to right, and then sweep around underneath the center, moving right to left. Stroke in a few "collars" under the last stroke extending to the bottom of the rose bowl. Keep the white side of the brush facing towards the top of the flower throughout. Tiny comma strokes may now be added around the center using the "knife" edge and working wet into wet, or, they may be added later when the center is dry.

Remove the white on a paper towel and load Broken Red, pull through Antique Gold Deep as before and pick up Snow White on the gold side. With the white facing the center of the rose, start from one side a little toward the back and pull a stroke, using gentle pressure at first, around the bowl of the rose to the center. Exert more pressure in the center of the stroke and come back onto the tip to finish off. Repeat this stroke to fill the bowl, as required, underneath the first stroke. Repeat both strokes on the other side. (If a third stroke is needed to fill the area, go for it!) You may now

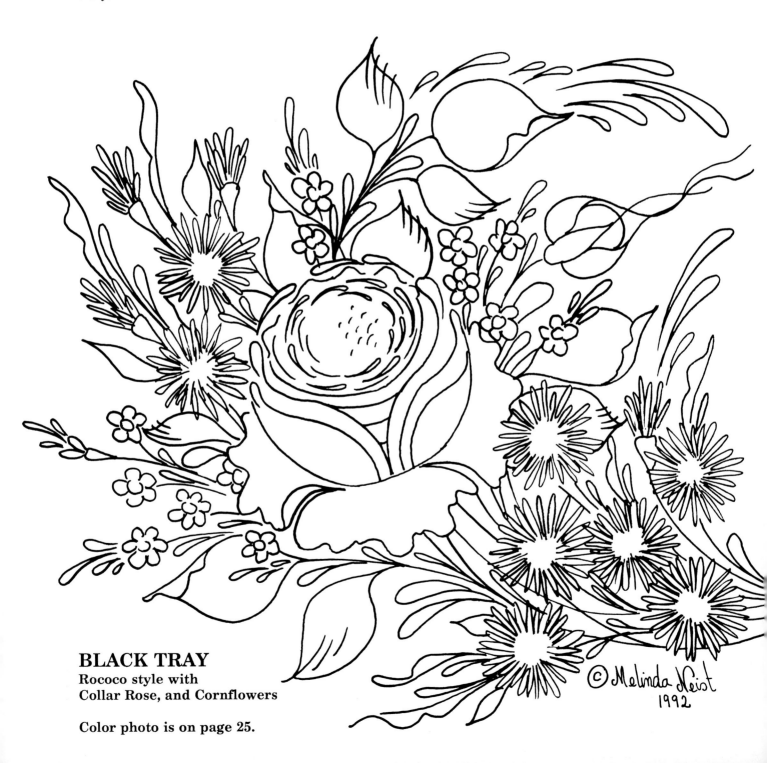

BLACK TRAY
Rococo style with
Collar Rose, and Cornflowers

Color photo is on page 25.

© Melinda Neist
1992

add a #13 stroke, single or double skirt as described previously, or you may wish to use the "Frilly Skirt" described next.

The "Frilly Skirt." Reload for the skirt using the same order of paint on the brush; however, this time go a little heavier on the white. Turn the flower upside down before painting the skirt. Study the color worksheet carefully here, and notice how the white is gently allowed to "dribble" off the brush as the shape of the skirt is "pushed" onto the surface, one petal at a time. Remove excess white before pulling the petal into the bowl by opening the brush and pushing up into the wet, white ridge, then, pulling back in the direction from which the petal "grew." Try to imagine that you can see right through the flower. Visualize where the top of the stem would end. Direct your strokes towards this point when pulling the skirt towards the rose. You may wish to turn a petal back to add interest. The technique is exactly the same as for turning a leaf. Remember to keep the brush with a sharp knife edge with white on one side and the darker flower color on the other.

THE THREE PETAL ROSE (Worksheet on page 41)

Repeat the steps described for the center of the Collar Rose. Wipe the brush and reload with Broken Red, pull through Antique Gold Deep, and pick up Snow White on the gold side. Keeping the white facing the top of the rose, push a few little bumps around the top of the rose using only the tip of the brush (Stroke #13, recognize it?). Replace the white on the white side of the brush and, turning the white towards the center, lay a few little blobs around the right side of the center. Face the white side of the brush to the ceiling, push up into the last white blob, and pull down. Repeat once, maybe twice, moving up towards the outer right side of the rose to form the right side petal. Reverse the procedure to form the left side petal.

For the center petal, replace the white and "dribble" a few white blobs around the center-front from the left petal to the right and overlapping slightly. Turn the white side to the outside and pull a rounded stroke downwards on each side to shape the petal. Turn the white side of the brush under, push upwards into the center white blob, and pull down. Continue in this manner on either side of the center stroke to form a single petal. Tiny comma strokes may be added around the center using the knife edge of the brush.

If you wish to add an extra side petal to dress up your rose a little, you may do so; however, use these and other embellishments, such as turned petals, sparingly. Too many "extras" will tend to cause the flower to become very "busy" thus detracting from the elegance of your design. Study the color worksheet. Do you notice that an extra petal, holding close to the rose, is achieved simply by laying a #6 or #7 stroke on top of one side of the petals and curving the tail into the underside of the rose bowl? Reload for the skirt and continue as described for the Frilly Skirt or the #13 skirt. If you prefer a more open extra petal, this can be achieved by simply repeating the steps used to form the side petals. However, you will need to start a little away from the body of the rose.

Chapter 8
COLOR COMBINATIONS FOR FLOWERS
AND FOLIAGE

As this is a technique-oriented book, I have tried to simplify the explanation of procedures by maintaining reference to a very basic color scheme. Now that you are familiar with the multi-loading technique, and terms such as "picking up" and "pulling through" are fully understood, we can progress to many different colored flowers and leaves.

I have included a Foliage Chart, listing a range of background colors. If you wish to use a background color that is not listed, use the chart as a guide and select foliage combinations for a similar background color. For example, you have chosen to use Deco-Art's Peaches and Cream or Dusty Rose as a basecoat. Neither appear on the included background color chart; however, they are both very similar to Flesh Tone, which is listed. Therefore, you would choose a foliage combination from those recommended for Flesh Tone. A "+" sign means those two colors are mixed together. Highlight colors are added onto the brush, which is already loaded with the main leaf color, by using the "pull through" technique. For medium high-

lights, pull through the gold only. For lighter highlights (i.e. smallest filler strokes), pull through gold first and then through white *gently* on the gold side of the brush.

LIGHT COLORED BACKGROUNDS

An important point concerning light colored backgrounds needs to be explained; otherwise, they may present problems. Most flowers have a heavy white outline due to the painting technique used and, thus, are most apparent when painted on a dark background, especially black. However, this effect is totally lost on a light background. The raised, white, outer edges of a flower simply disappear.

With this in mind, always choose a design where the flowers are laying on top of darker foliage. If the design requires the addition of a few leaves behind the flowers to accentuate them, go ahead and add them. The leaves do not need to completely surround the flowers. Some open area is acceptable. However, the lightest areas of the flowers need to rest on top of the darker foliage.

BOOK COVER
Rococo style with
Collar Rose

Color photo is on page 9.

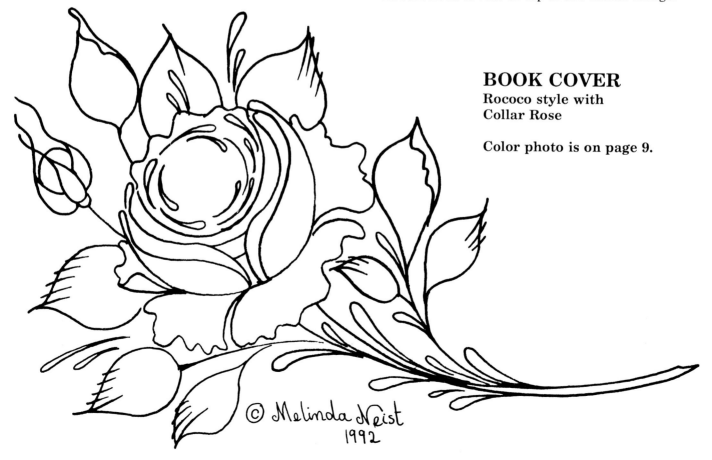

BACKGROUND COLOR	FOLIAGE COLOR
Georgia Clay	Red + black, gold and white for highlight, or Avocado + a little black, gold and white for highlight
Flesh Tone	Avocado + a little black, gold and white for highlight, or Red + black, gold and white for highlight, or Burnt umber + a little black, gold and white for highlight
Desert Sand	Avocado + a little black, gold and white for highlight, or Red + black, gold and white for highlight
Colonial Green	Evergreen + navy blue and white for highlight, or Navy blue + black, gold and white for highlight, or Black forest green, gold and white for highlight
Blue Haze French Grey Blue	Navy blue + black, gold and white for highlight, or Ultra blue deep + black, gold and white for highlight, or Viridian green + black, gold and white for highlight, or Evergreen with white as highlight
Blueberry	Navy blue + black, gold and white for highlight, or Ultra blue deep + black, gold and white for highlight, or Viridian green + black, gold and white for highlight
Ebony Black	Straight avocado, gold and white for highlights, or Avocado + white, gold and white for highlight (Lemon yellow + white may also be used for highlight)
Black Forest Green	Straight avocado, gold and white for highlights, or Avocado + white, gold and white for highlights (Lemon yellow + white may also be used for highlight)

Roses, Tulips, and Daisies can be painted using a multitude of colors. I will give the colors and brush loading sequence for some of the most popular and commonly used colors for each flower type. Refer back to the appropriate flower instructions and substitute the colors accordingly.

ROSES (including Tolzer Rose and Peony)

Desired Color	Load	Pull Through	Pick Up
Salmon Pink	Broken Red*	Antique Gold Deep	Snow White
Burgundy Tone	Burgundy Wine	Antique Gold Deep	Snow White
Orange Tone	Georgia Clay	Antique Gold Deep	Snow White
Yellow	Antique Gold Deep	Broken Red*	Snow White

*Note: "Break" Napthol Red with Avocado (green)

CARNATIONS, TULIPS, AND DAISIES

These may be painted using the same combinations as for Roses as well as the following:

Desired Color	Load	Pull Through	Pick Up
Light Blue	Sapphire	N/A	Snow White
Mid Blue	Blueberry	N/A	Snow White
Deep Blue	Navy Blue	Antique Gold Deep	Snow White
Yellow-White	Antique Gold Deep	N/A	Snow White

CORNFLOWERS are always painted as described in Chapter 6 using Ultra Blue Deep and Snow White.

COLOR CONVERSION CHART

Please be aware that these color comparisons will be close but seldom exact. To simplify my instructions I have referred to a single brand of paint through out this book, that brand being Deco-Art and in particular their Americana and Enid's Collection range. Therefore, the color conversion chart is keyed off the Deco-Art Americana colors so that you can find a corresponding color in your preferred brand.

DECO-ART AMERICANA	DECO-ART TRUE PIGMENT COLORS and ENID'S COLLECTION	ACCENT and ACCENT BLENDING COLORS	JO SONJA
Snow White	Titanium White	Titanium White	Titanium White
Lemon Yellow	Yellow Light	Yellow Light	Yellow Light
Special Mix *	Antique Gold Deep	Special Mix *	Special Mix *
Napthol Red	Brilliant Red	Napthol Red Light	Napthol Red Light
Georgia Clay	Oxblood	Pennsylvania Clay + True Orange	Norwegian Orange + Red Earth
Burgundy Wine	Deep Burgundy	Burgundy	Burgundy + Napthol Red Light
Ebony Black	Lamp Ebony Black	Ebony Black	Carbon Black
Avocado	Antique Green	Pine Needle Green + Green Olive	Pine Green + Yellow Oxide + White
Viridian Green	Blue/Green	Pthalo Green	Pthalo Green
Burnt Umber	Burnt Umber	Burnt Umber	Burnt Umber
Desert Sand	**	Off White + Wild Honey	Smoked Pearl
Sapphire	**	Sapphire	Sapphire Blue
Ultra Blue Deep	**	Ultramarine Blue Deep	Ultra Blue Deep
Blueberry	**	Blue Bonnet + Pure Blue	Prussian Blue + Amethyst + Titanium White
Navy Blue	**	Windsor Blue	Prussian Blue
Flesh Tone	**	Light Peaches & Cream	Warm White + Gold Oxide
Colonial Green	**	Village Green + Ultra Blue	Jade + Ultramarine
French Grey Blue	**	Stoneware Blue	French Blue + White
Glorious Gold (Metallic)	**	Imperial Antique Gold	Rich Gold
Black Forest Green	**	Deep Forest Green	Teal Green + Green Oxide
Evergreen	**	Pine Needle Green	Pine Green + Black

* Antique Gold Deep can be mixed according to the special formulas described on the next page.
** Use the Deco-Art Americana color.

MIXING ANTIQUE GOLD DEEP

Deco-Art Americana. To one 2-oz bottle of Cadmium Yellow add 7 drops of Ebony Black and 6 drops of Napthol Red.

Accent. To one 2-oz bottle of Yellow Light add 7 drops of Ebony Black and 6 drops of Napthol Red Light.

Jo Sonja. Squeeze a tube of Yellow Light into an empty 2-oz bottle. Take any bottle acrylic (this is just for size comparison only, so any color will do) and pour seven drops onto a palette taking note of the resulting blob. Squeeze a similar size blob of Carbon Black and a slightly smaller blob of Napthol Red Light onto a palette. With a palette knife scoop the black and red blobs of paint into the bottle of Yellow Light. (This color is already available in Australia as Antique Gold.)

In each case above, stir your new color vigorously with the end of a paint brush until completely mixed. Don't be tempted to simply screw on the lid and shake the bottle as this will only cause the black and red to stick up inside the lid and will prevent a proper mix.

BOX
Rococo style with
3-Petal Rose with
Frilly Skirt

Color photo is on page 48.

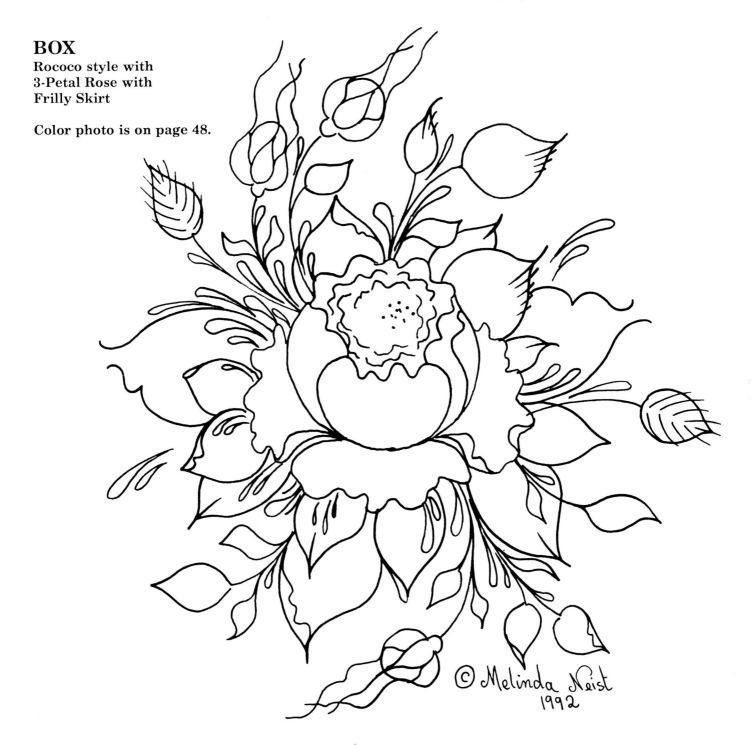

© Melinda Neist
1992

BOX
Pattern
on page 47

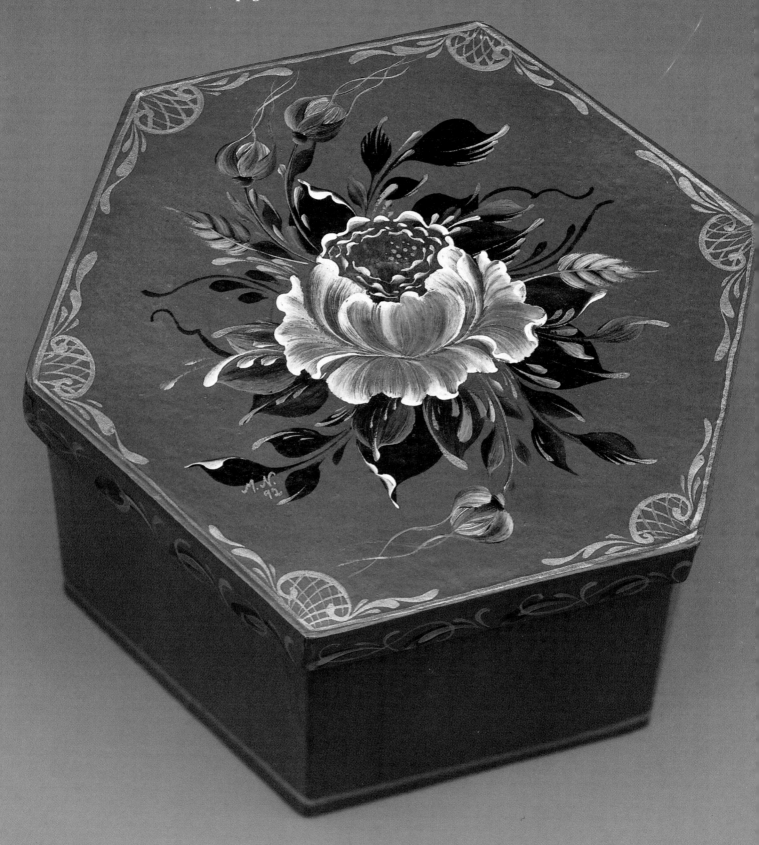